Feather Prisms

Acknowledgments:

Thanks to the friends, loved ones, and events in my life that inspired my writing. Thanks to my parents, Sheila and Narendra, for their love and support. Thanks to Serene for her love, for encouraging me to get my photos out there, and for an editorial eye. Thanks to the earth for her abundance and beauty. May all human beings again know her well, and come back into balance with her.

Copyright © 2009 by Anasuya Krishnaswamy

The writings and photographs in this collection were created by Anasuya Krishnaswamy. All rights reserved. No part of this book may be reproduced, stored, or transmitted by any means—whether auditory, graphic, mechanical, or electronic—without written permission of both publisher and author, except in the case of brief excerpts used in critical articles and reviews. Unauthorized reproduction of any part of this work is illegal and is punishable by law.

ISBN 978-0-578-04163-6

Book design, cover design, and cover photos of sand and sea: Anasuya Krishnaswamy
Back cover photo: Tracey Campbell

Feather Prisms

Original Poetry and Photography
by Anasuya Krishnaswamy

"For now he knew what Shalimar knew: If you surrendered to the air, you could *ride* it." – Toni Morrison, *Song of Solomon*

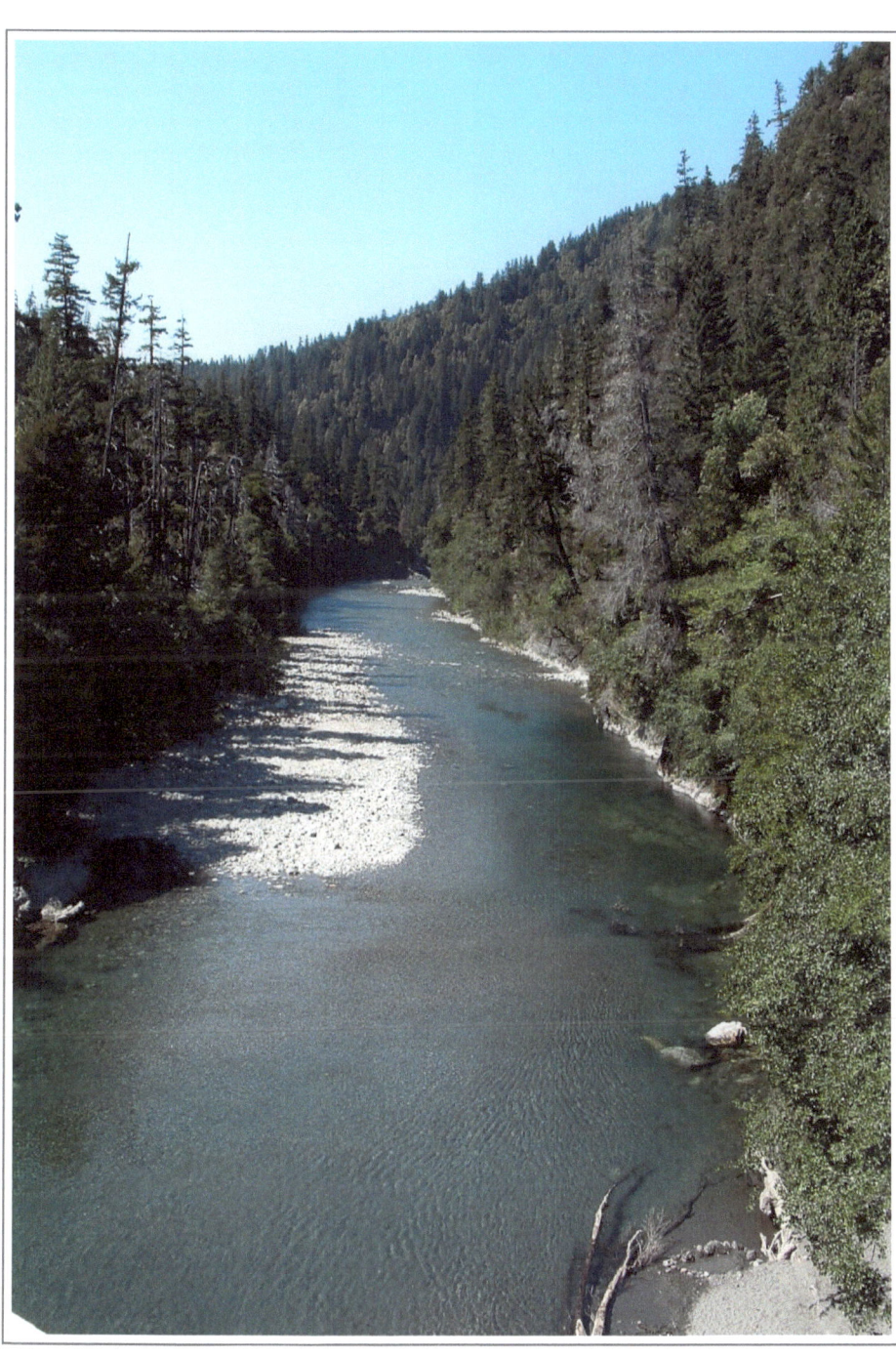

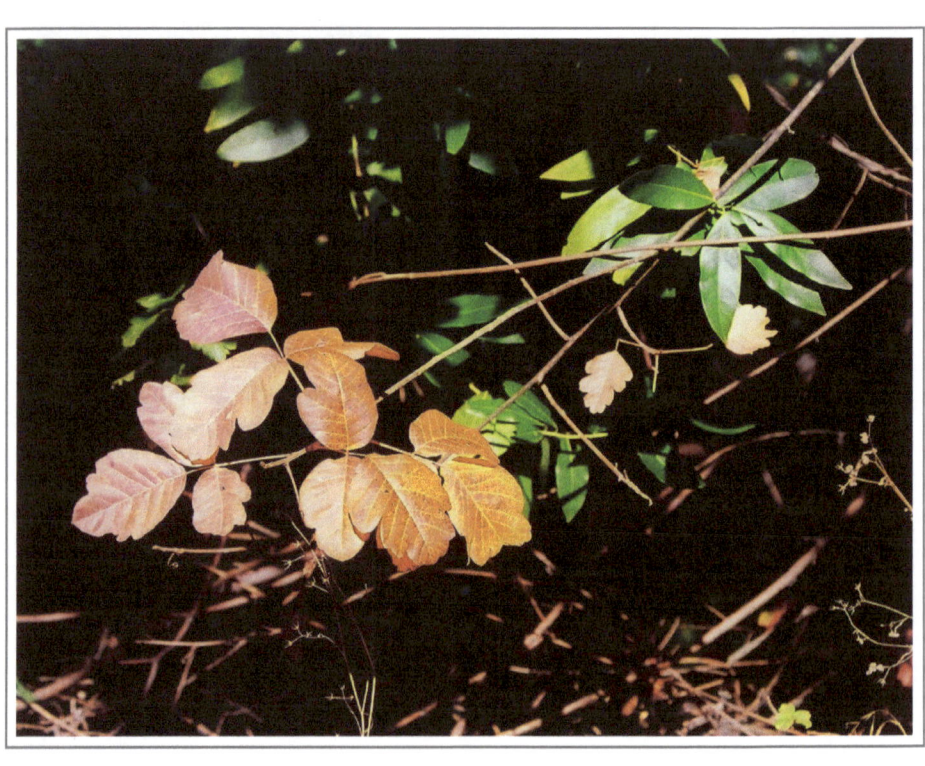

Fall

When the poison oak leaves
Burn crimson and fall away
And acorns drop
Doe and buck seek the nuts
of fruitful oaks
And I must prepare for
Swift change
Or accept it when
Like a gusty spirit wind
It knocks me down
Then crawl to find an acorn
Chew the bitter bud
Swallow
Digest
And get up again

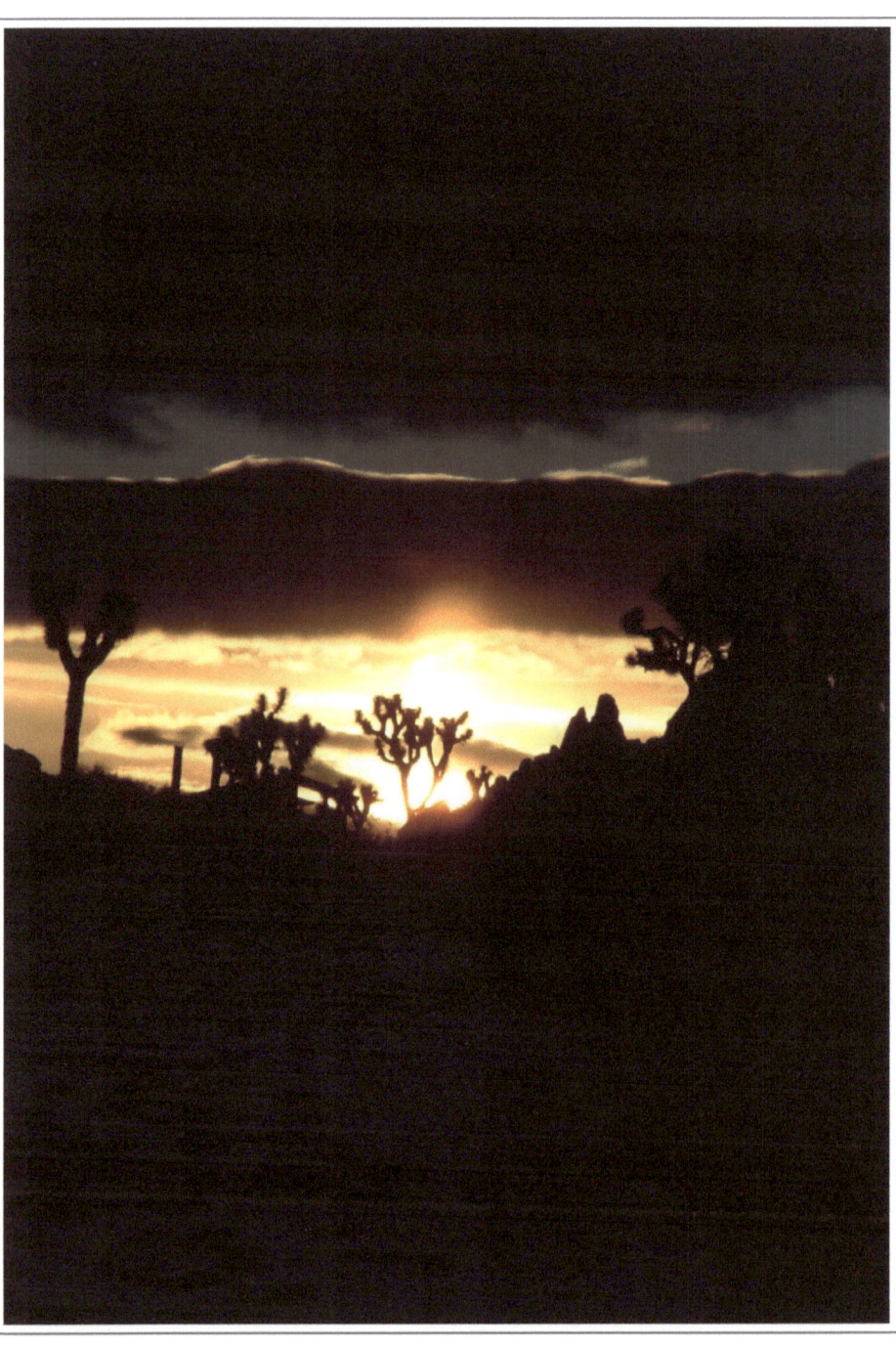

Retreat

She rises a few hours before the guests
Her feet touch the hand woven rug
smuggled like her brother
Across a dusty border
It is the jewel of the little house
Keeping dust from rising too aggressively
from the dirt floor
The kettle hums and hisses,
hot water ready for the bath
She will cook eggs this morning
Fluffy, moist with a pinch of chili powder
Some onions and peppers, sautéed soft
She will peer at the guests through an opening
cut in the kitchen wall
Meant for the guests to see her
The guests will dribble in, sleepy-eyed and sullen
Before their freshly brewed Guatemalan coffee
Toast feet that were warm last night
Toast feet
By a roaring fire
Until they can hardly stand the heat
Sip and stare and murmur to each other
Someone will suggest they go to the hot tub later
They will all agree, yes we must, to relax

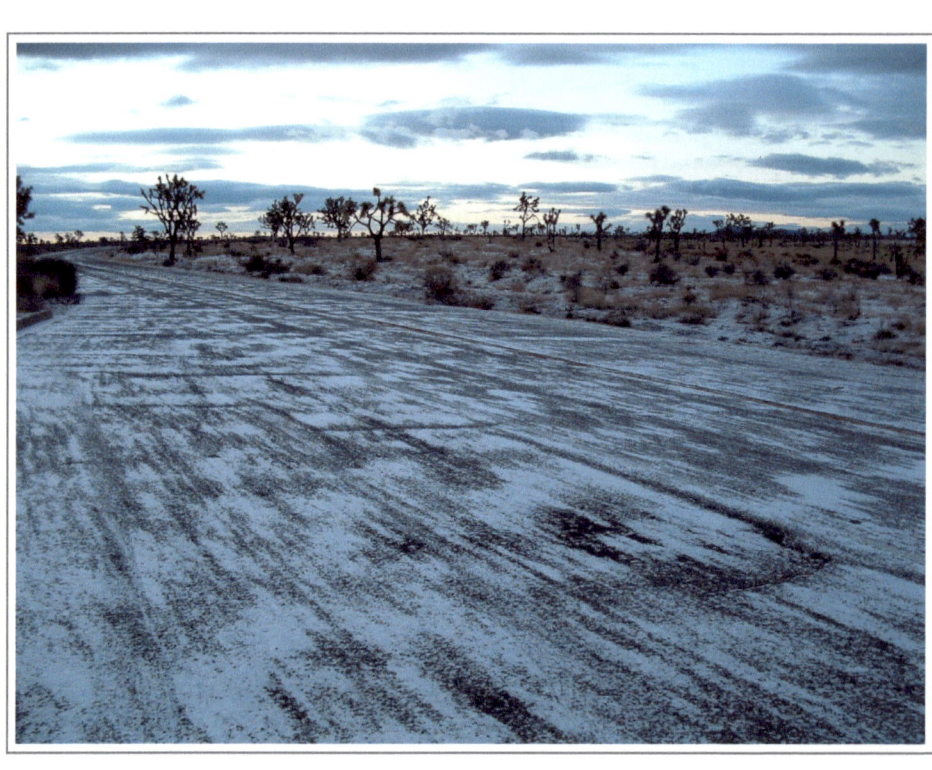

Desert Dreams

Desert colors sprayed about
Violets, magentas, pastel pinks
From mountain ridges, saguaros
Joshua trees and chaparral leaves
Desert brush line washes
Leaves aglow in the winter light
We have come from the temperate zone
of bay and coastal range
Through the flat lands
To the foothills dotted with spidery oaks
And then beyond
Fingers of eroded land greet the valley floor
We climb them to the dry high desert
Through the mountain pass
Feathered with snow
Landscapes shift in a moment
Desert shapes seem timeless
Desert colors are elusive
But leave a permanent impression

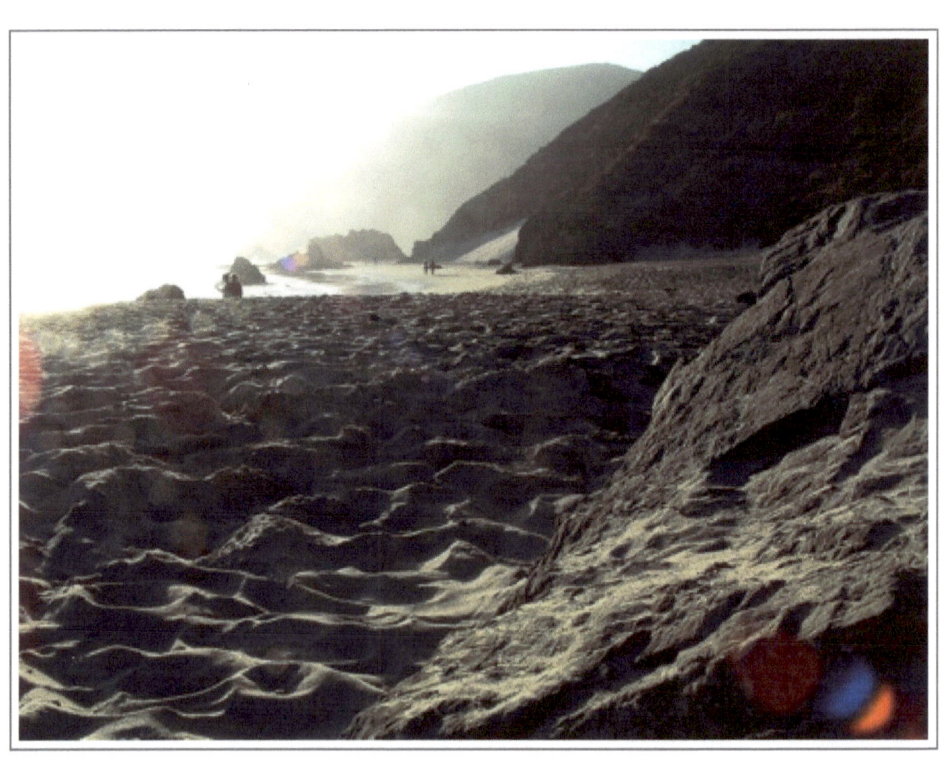

Misty Afternoon on Baker Beach

I
Playing Catch with the Football

The wet leather
Dipped into the winter ocean
Each time we fail
Strikes my hands and smarts
Spirals are impossible

The game is to rescue a dropped ball
Before the next wave interferes
And kidnaps Mr. Hail Mary
Sending him helplessly
Out to sea

Mist at times closes in
Target erased momentarily
I play blind quarterback
Until it leaves again
Or settles in

II
Lovers

A private universe under the blanket
The solar Madame's rays reach out in approval
Her winter touch gentle and warm

Leg wrapped around leg
Arms full of holy flesh

Tomorrow and the next day
Little grains of sand
Will reveal themselves
In shoes, in pockets, in private places

III
Meditation

Huge swells, winter surf, crash on the shore
A collision between earth and water
Presided over
By the tempered fire
Of the winter sun

The sound of waves striking
Is a million miniscule cymbals
Banging together in a round
Orchestrated by no one
Evolving from the inevitable rhythms
Still reverberating
From a creative force

Tendrils of fog weave in and out of the bluffs
Dancing with the land and sea
The fog is tender and the surf crazed
The soul tempering the madness of the mind

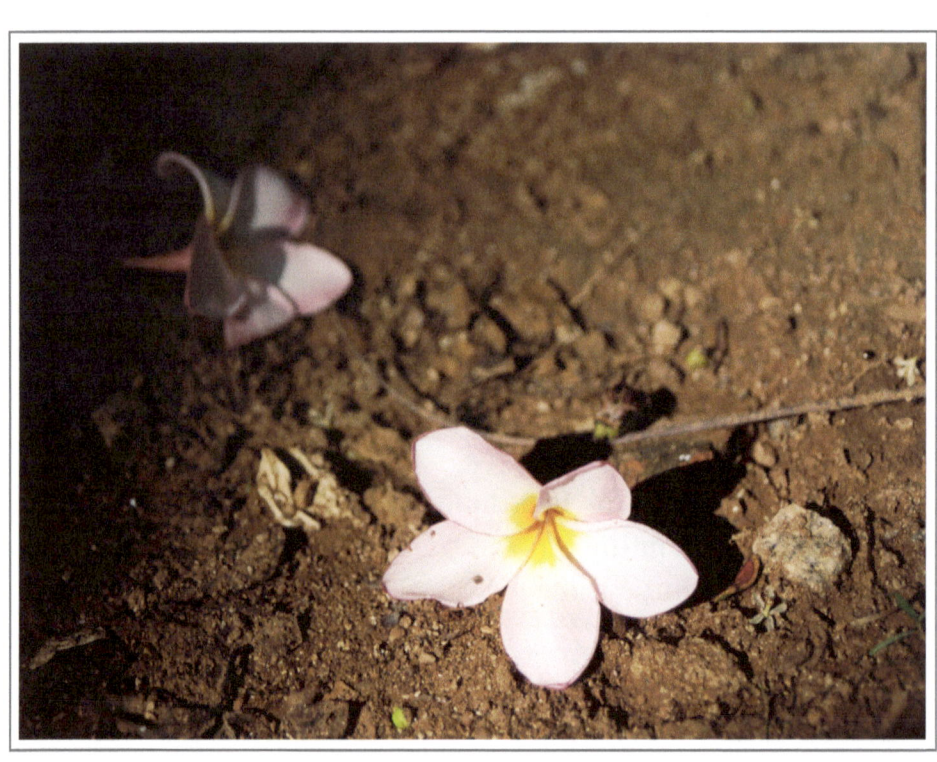

Possibilities

It's like a huge plumeria tree bloomed all at once
The velvety petals of its flowers plump
The inner markings clear and bright
The petals absorbing and reflecting at will
And then what
For you it became so full and big
That it was going to eat you alive
Devour you, leaving no you, no space
And all the while I'm smiling at this
Beautiful flower
Imagining it larger than life
And connected
To its stem and other stems
To its roots
And wanting to explore its entirety
And you wanting to behold a smaller
more withered bloom
In check, manageable, not too scary
And maybe I don't see the danger
See the gigantic bloom gone crazy
And maybe you don't see the possibility
Of the plant

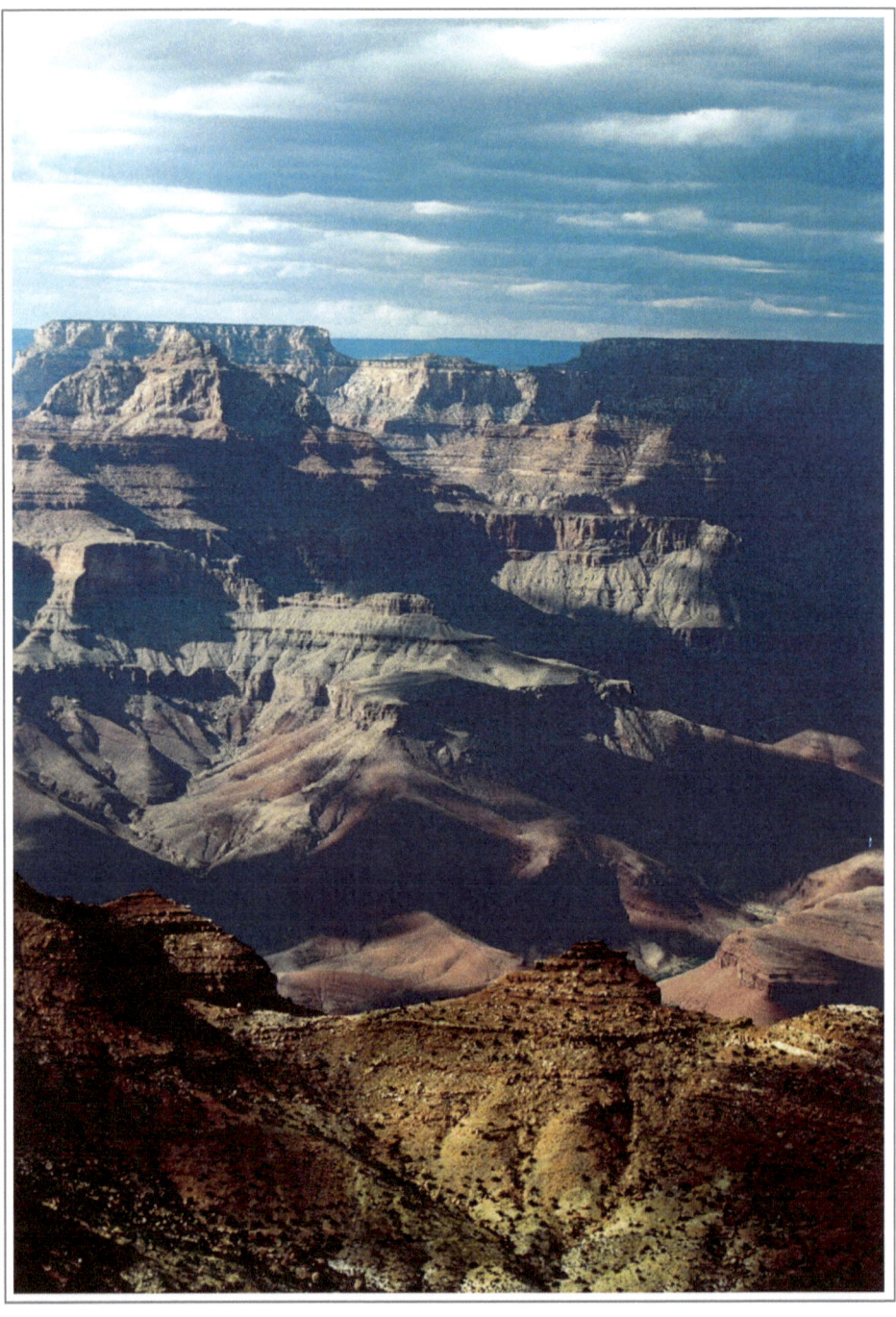

Womb

She grows out of this motherland
Maybe she sprouts new leaves
But her roots took hold
Long ago

A small child smells the peppery earth
on her grandfather's farm
She digs with her mother for arrowheads
in the morning mud
Finds jade and deer bone dice and obsidian chips
She picks blackberries in the dry creek bed,
fingers turning a delightful purple
Sees the arroyo decorated with oak balls
In fourth grade she goes camping with her class
They sniff bay and laurel leaves on their walks
Hear the murmur of hillside streams
Gather acorns under a nurturing oak
and make acorn mush

She dreams of walking with ancestral people
Not hers by blood, but hers by land and spirit
They fish a salmon run in a stream that feeds the
bay
Walk a deer path through six-foot tall grass on the
hillsides
Note the smoke signals,
predecessor to a yellow brown haze

Womb cont.

The mountains whistle to her
Granite pushed up, iced over,
lesser rock rubbed away
Scents of ponderosa, pinyon, and sugar pine
Red-iron soil

The desert whispers to her
At higher elevations bristlecone pine and juniper give way to
Organ pipes, saguaro, and the cholla
Golden needles aglow in winter light

The rivers and oceans sing to her
While she dips toes in icy run-off
and wades in warmer pools
Gurgles and cascading rhythms
Drumming waves and a wind whipped coastline
Surging forces that have shaped rugged cliffs for eons

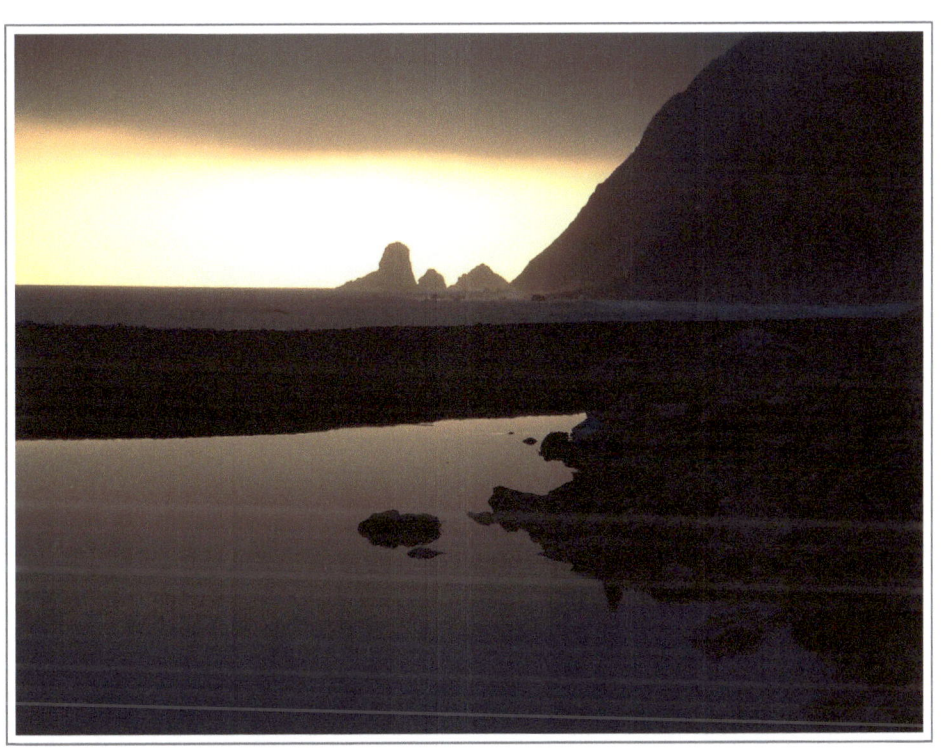

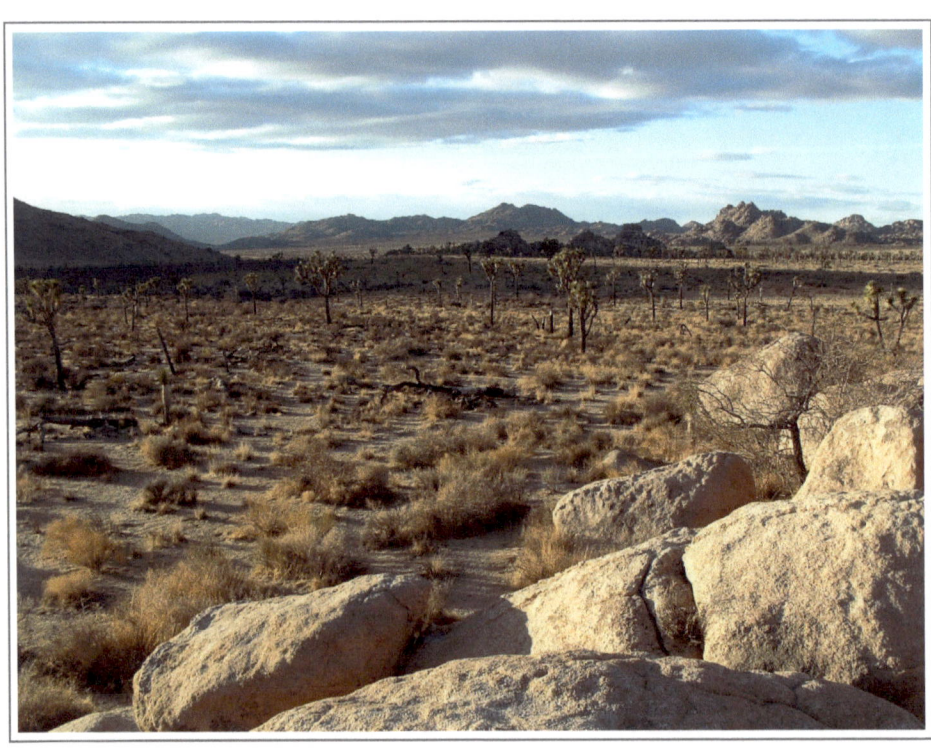

Frozen

She sweats mad under
But does not speak
What lines will shake him?

Assumption
Denial

Futile words drop
Like a desert rain
On the hard packed earth
They gather and swim away

She wants to return
To the sweet place
Of honesty and funky rhythm
But awakens
To the possibility of no return

Anger

He manipulates the shadow moments
Sweet symphony of honey dreams
Smeared brilliantly
Like tongue on petal skin
Bitter language leaves scars
A voice lingers seeping soft poison

Shame

A cold ache for the self who dances
Moist woman, girl and boy
Time incubates a green fool and
Men who walk a velvet road
Can crush life essential
Do not let it rob you sister
Celebrate your naked breasts
Remember to rock in the rain and laugh

In the Muck

This is the dark green pool
Haunted by ferocious chants
It will devour
You want to swim away
But tonight you go down into it
Purple steel knifes through pink smoke
Bitter liquid smiles sail above
Mad blazes lick the wounds
Until fingers of mist stream in
Morning whispers out the fever
Your heart beats to a brilliant peace

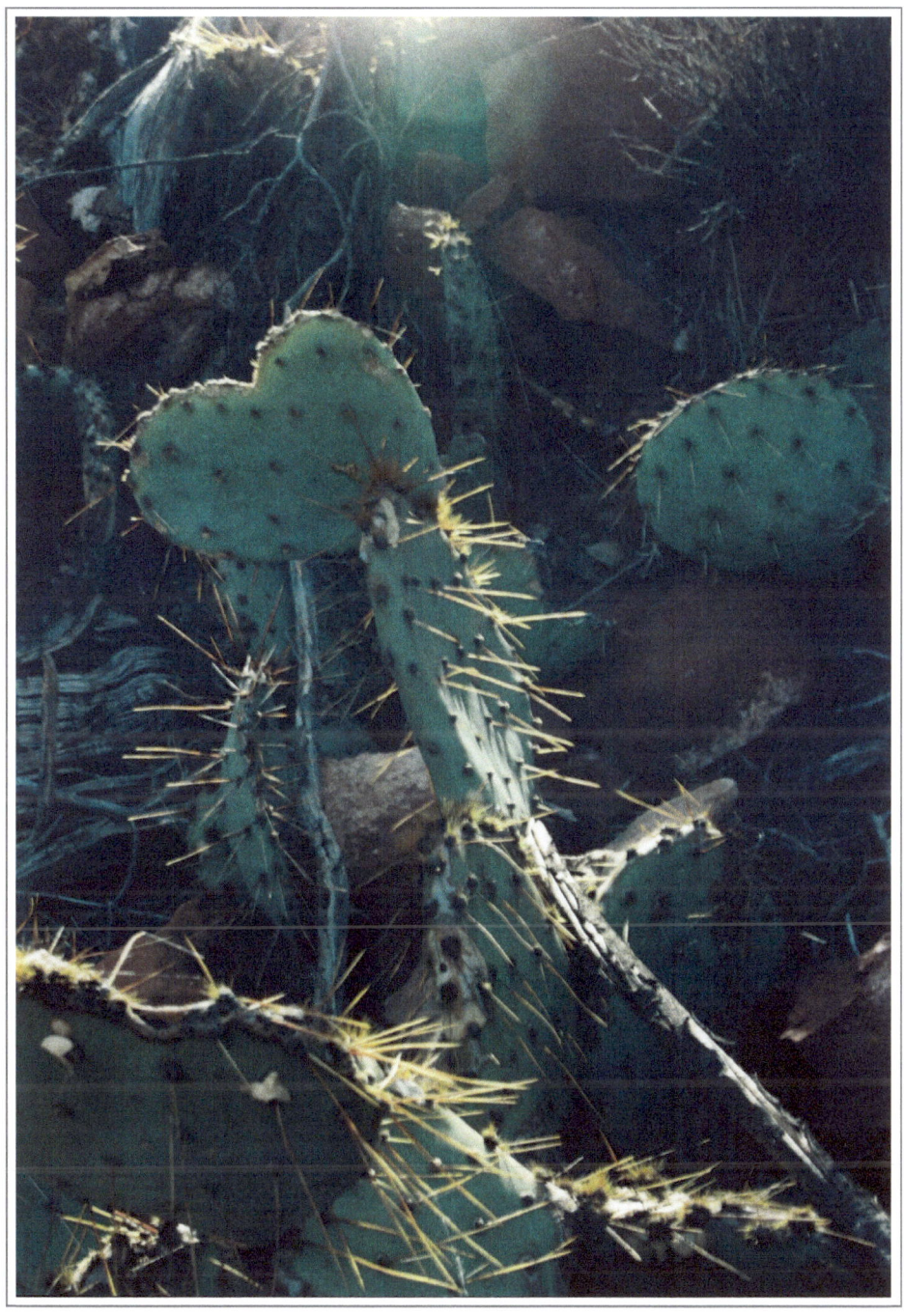

For Julie

Her babe tumbles
And there will be no picking up this time
No retrieval
Like magnolia flowers dropping in a pond
He is beautiful all the way through the fall
Beautiful when perky petals sit high up on cheerful branches
Beautiful when edges roughen and the heart is bruised
From living
He is beautiful in his tumble to the water
And the ripples will carry his beauty to the shore

Joy

Manic depressive
Bipolar
Schizoid
Schizo
Just damn depressed
What's the disease of joy?
Bloppity blippity blop
Infect me with it
Resonate
Percolate
Permeate
Don't hesitate
Run for it
Grab your bliss

Faces of the Source

Crunch of fallen leaves under foot
Click of stiletto on cement
Brush of fleece, fur, fluff on fluff
Wick of nylon, the creak of leather armpit
We walk
To the classroom
To the construction site
To the office cubicle life
Soft sunlight hits
Bouncing brilliant, blinding reflections
from the tops of high rises
Illuminating intricate facades of Victorians
and minimalist flat tops of modern lofts
Splitting across domes and spires
We spin before our home star
The rays go from soft to intense and soft again
While we're busy teaching
Building
Staring at the computer
We walk, drive, ride the road to home
Wanting to see the T.V. screen
The tube that reminds us why we need to do it all
over again

Peacekeepers

War on terror
War is terror
Insurgents
Defenders
Occupiers
Freedom Fighters
Revolutionaries
Patriots
Peacekeepers
Where are the peacemakers
What am I?
While I stand by

We surround the city
Is it free
Or besieged
Beheaded
Naked human pyramid
Let's watch you masturbate
"'Soldiers who removed the bomb experienced symptoms consistent with low-level nerve agent exposure,' U.S. officials said."

We have a military
They have militants
Their bombs are rigged
Ours are designed with skill and for precision

Power transfer
Sovereignty
We do not want to be in the business of nation building
We just want to be in the business of nations
When will we be in the business of building schools and places to heal?

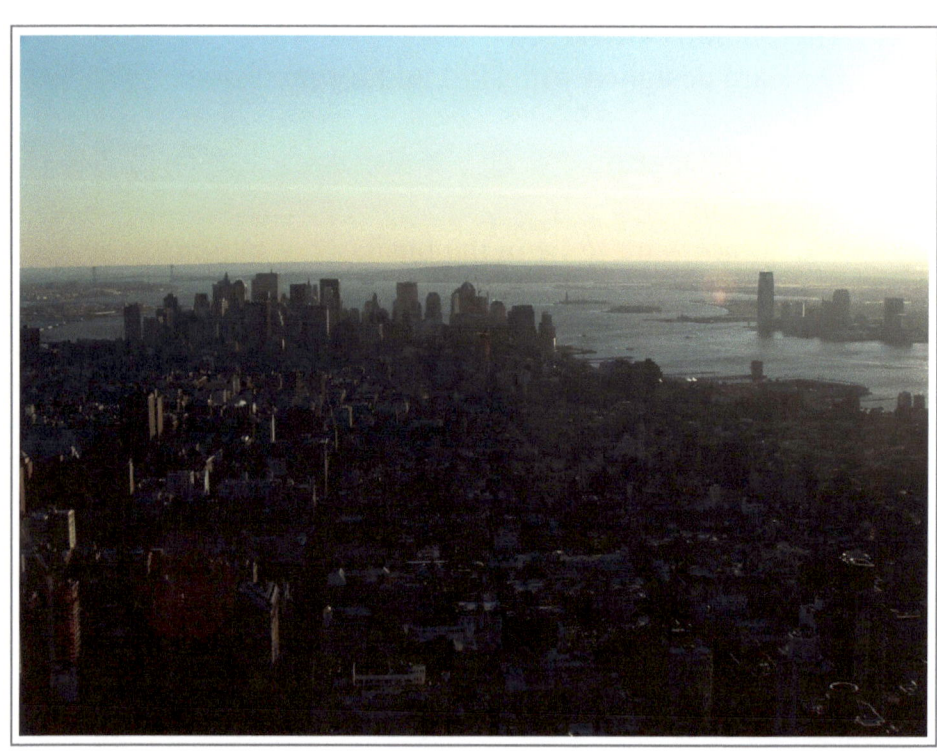

Label

Minority
Minority rights
Minority statistics
Minority report
Minor
Meaning not major
Not most important
Not mainstream
Not mattering

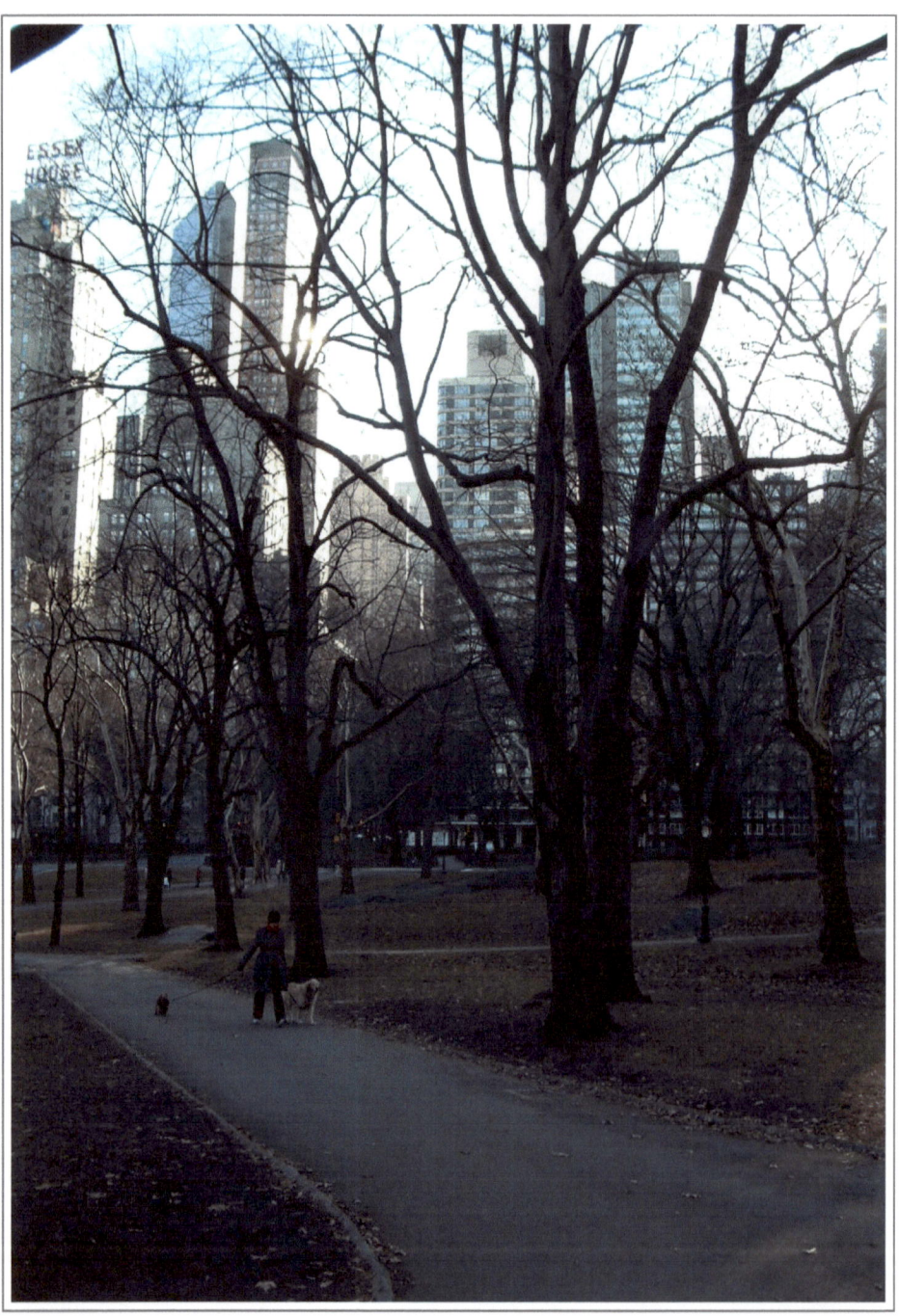

A Fresh Worm

Birds in the Prison Yard
Land on barbed wire
They are free to fly over
Never to return
But, like clockwork,
they will circle overhead
When people congregate in the yard
Hoping for a crumb or drop of blood
Fly away as the yard empties
And return again
Preferring the artificial leftovers
To a fresh worm

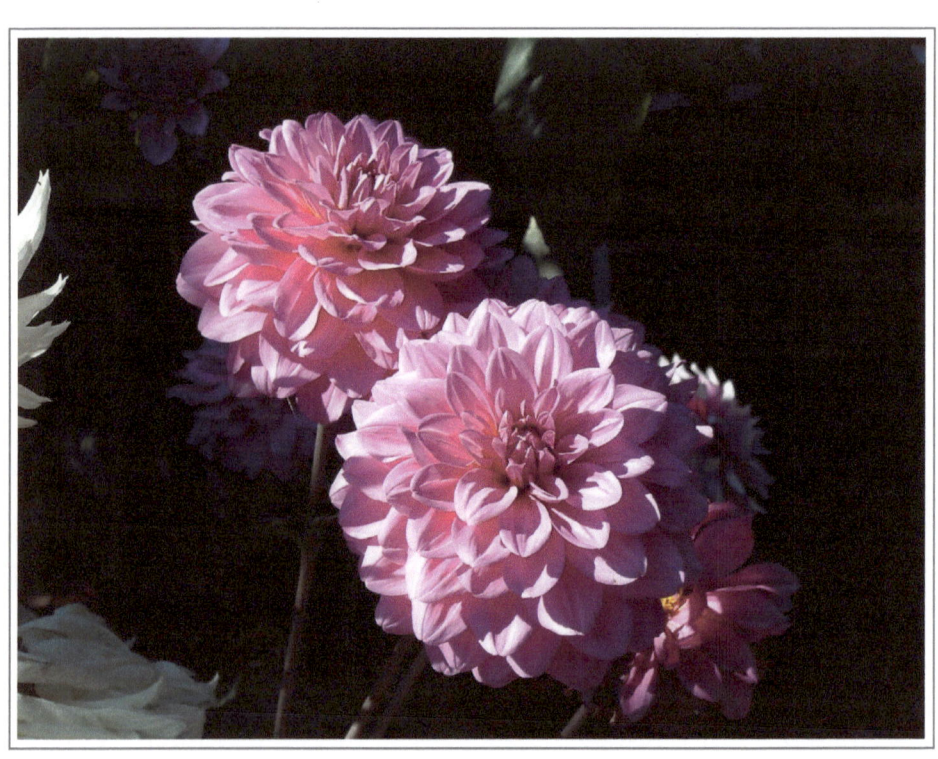

Child

In a manicured place
Rodin's twisted figures
Throw out the guts of life
We sit and watch the light
Roll across the day
The wind skip through the garden

Three couples stroll by
Each with a baby
Their paths crisscross
Each a little family

Don't you want a child?
He asks
I say
I'm open to the possibility
Now that we're not together
There's less of a guarantee

I think that's so sad
He says
And I ask
For you or me?

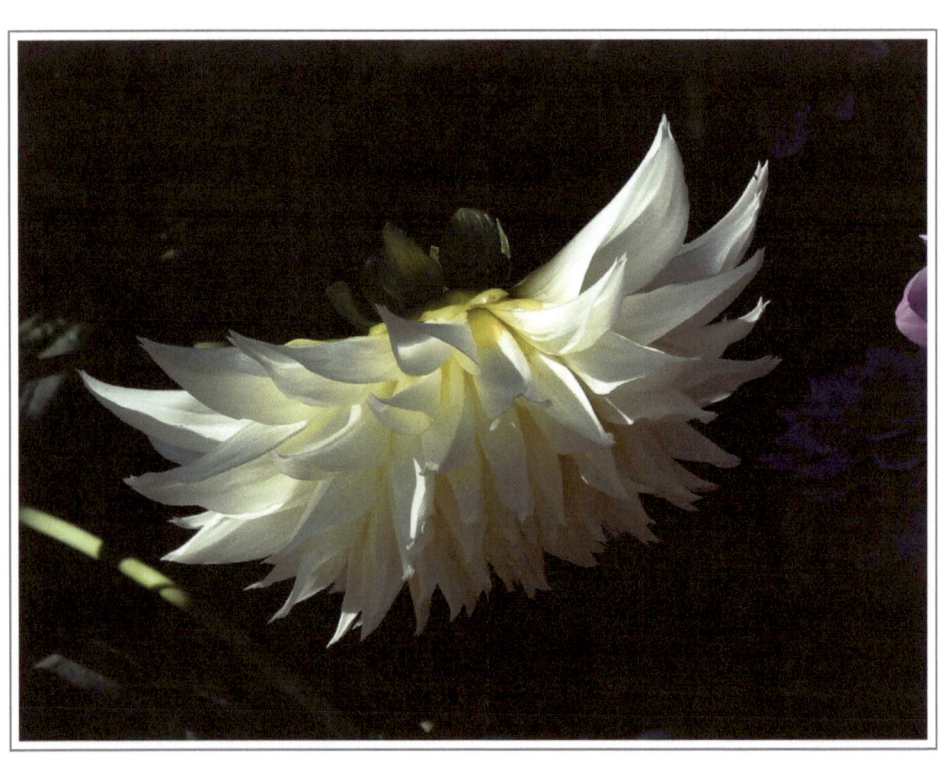

Woman

Beauty breeze
Blows honey kisses
A bare woman
With child blush
Speaks her truth
A sacred fool
Laughs angel love to the universe

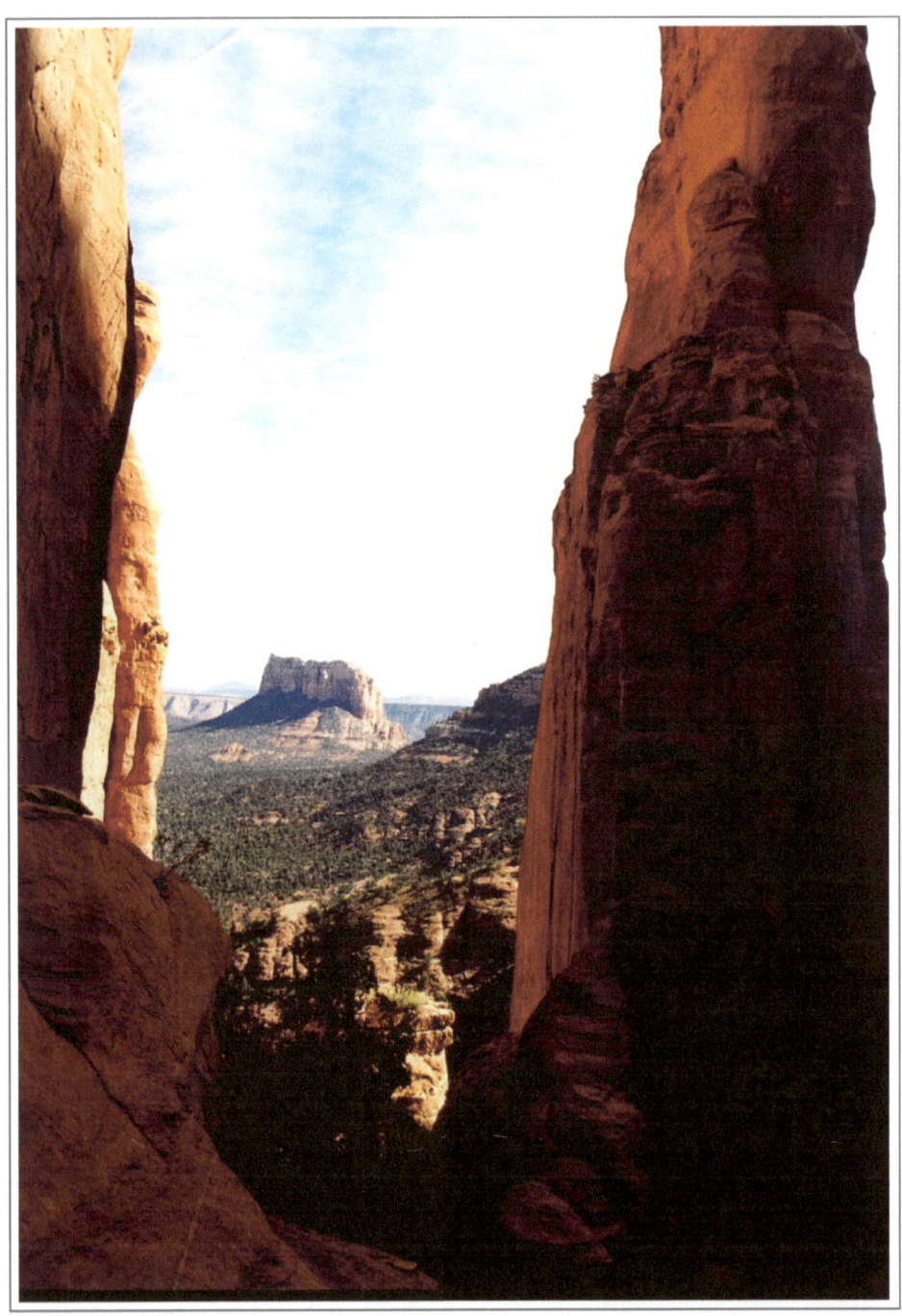

Yin and Yang

I
Man's voice penetrates
Her sounds and wisdom muted
She must stand, command

II
We grow older when
Loss shadows the open heart
Til it bursts again

III
These fish do not see sky
Or open road
They butt against the still lake
And swim downstream

IV
Embrace animal beauty
Daughters and sons
Streams of eternity
Scream on

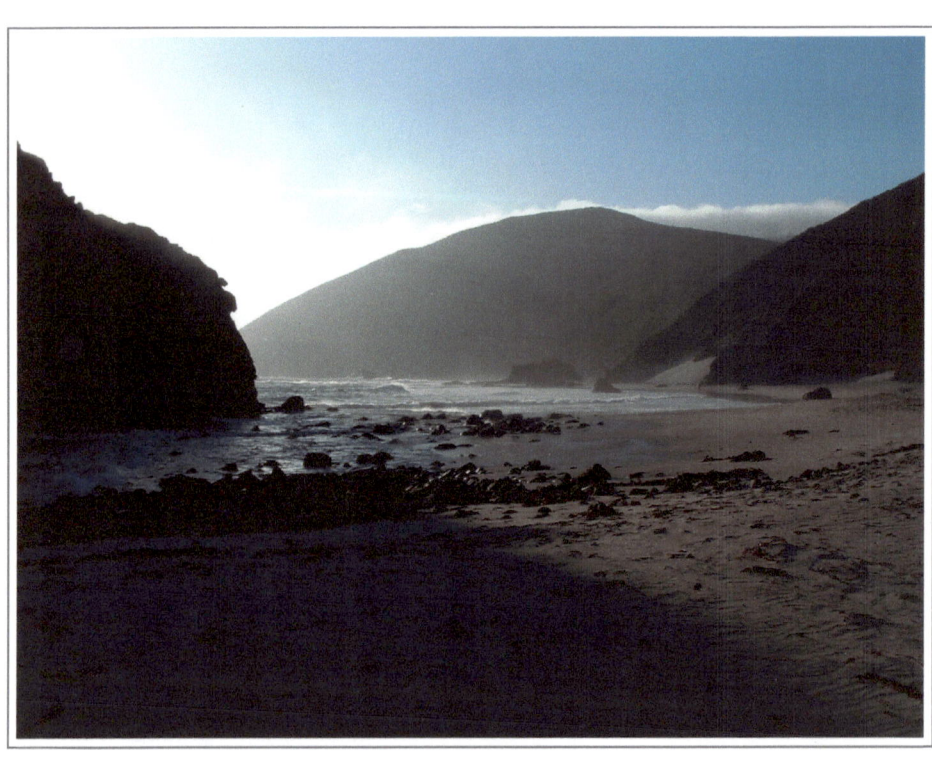

Feather Prisms

In the ocean waves
A thousand voices play
Cymbals laughing
Castanets taunting

Through the trees
Brass winds roar, whisper, sigh
Lyre string branches moan

Sundown rays glint and sparkle
Through birds' wings
Feather prisms

As the sun melts into fog and sea
The aquamarine and vibrant sky of midday
Soften into silver and violet blues
Now the hills are dark
Their shadow sharp
Against the wrinkled salt water
And the fog marches in

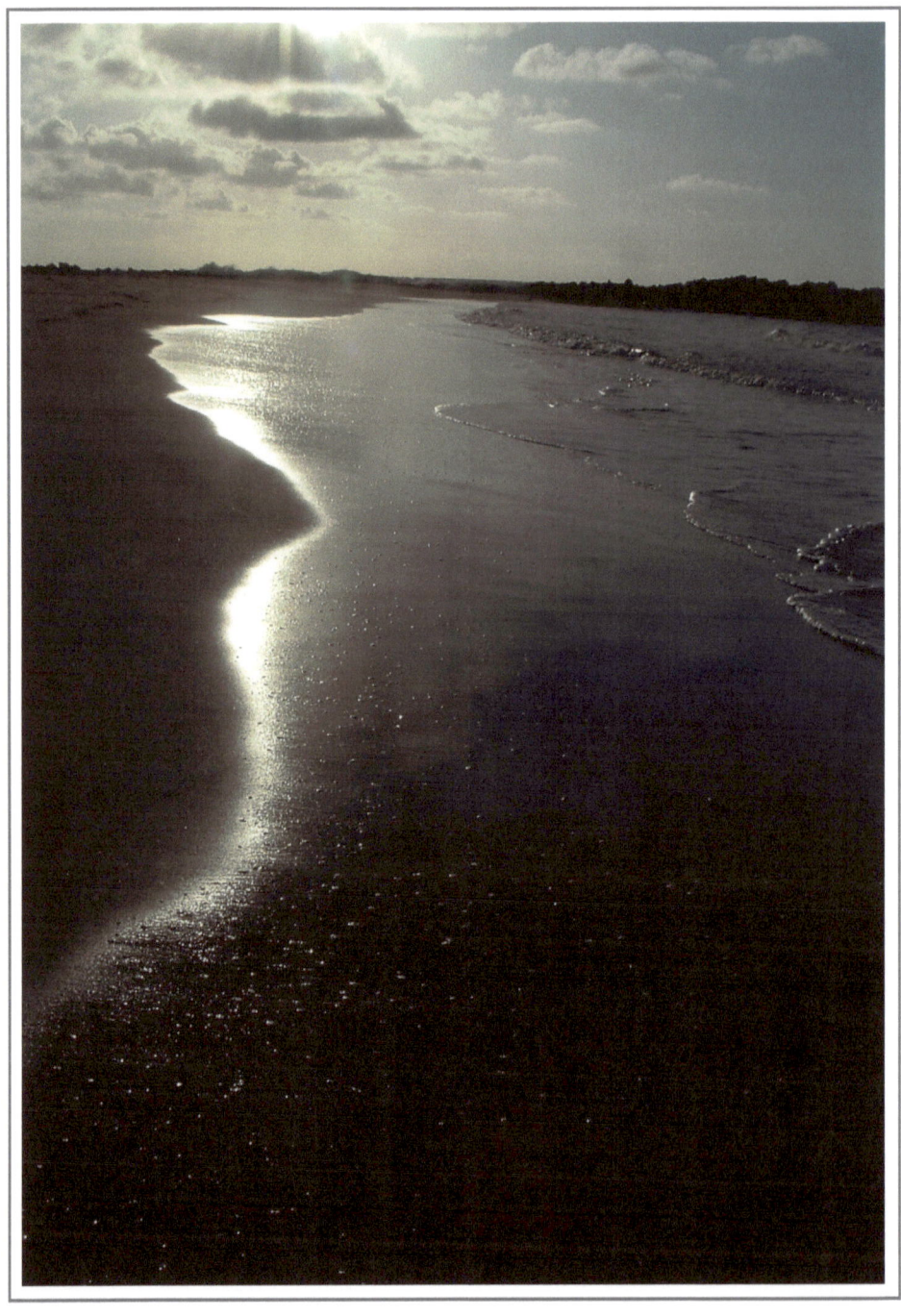

Water Dance

How the water dances
Curls and tumbles
With abandon
Joy it seems
There is direction
And surrender
The edge skims up the shoreline
A graceful pause
And then gives in again
An unearthly rhythm
Amidst the smooth sway
a whirlpool forms
Where ebb and flow meet and swirl around
A crisscross of fronts
A different piece of shoreline in mind
White foam flares on the surface
Air
Squeezed
Breathed
Before the next dance

Lizard Played Today

In this moment my love's a cat
Still life
Luxuriating in the sun
Stretch…ed…out
Wind dances up the canyon
Ruffles, rattles the trees
Passes
Comes again
Sun loops low, falls toward the horizon

Lizard played today
Green belly
Raised toes
Who knows
She could hear us
Invited us to stay

Sun loops lower now
Ends of pine needles glisten
Turned toward the last rays
Granite, quartz, ancient lava is still
As am I in this moment

Someone Else's Universe

Moon play and sun dance
There is order here
Where I inhabit
But sometimes a chaotic tune
Moments of alignment
Construction, dismantling, and reduction
Earth, sun, guiding star
Pull and push
Fling me to the edge of someone else's galaxy
I am a boomerang
Pummeled, stirred, aloft on a primal wind
Memories erased in a burst of
New light
New woman
Old world
Many lives

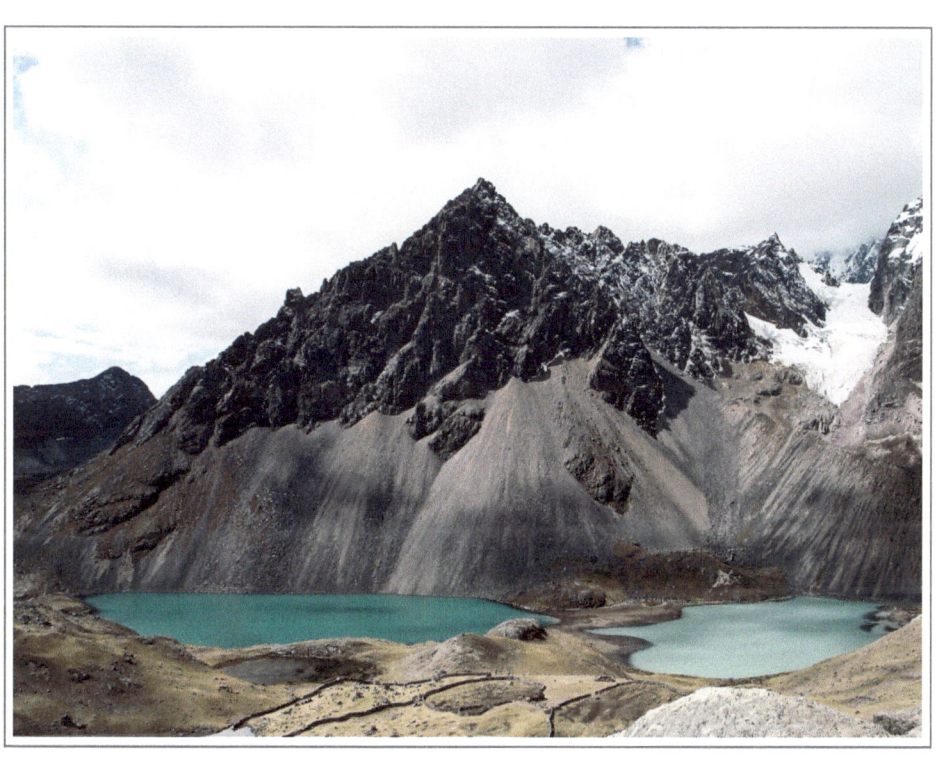

www.ingramcontent.com/pod-product-compliance
Lightning Source LLC
Chambersburg PA
CBHW041111180526
45172CB00001B/199